MCLACHLAN

DO NOT BEND, FOLD, STAPLE OR MUTILATE IN ANY WAY THESE WALLS

GRAFFITI:

THE SCRAWL OF THE WILD

The great graffiti of our times
collected and introduced by
ROGER KILROY

Illustrated by

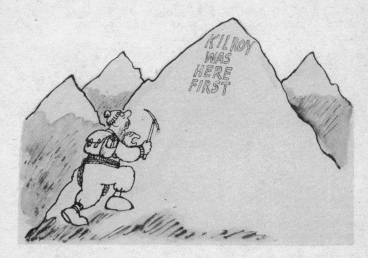

CORGI BOOKS

GRAFFITI: THE SCRAWL OF THE WILD
A CORGI BOOK 0 552 98079 X

First publication in Great Britain

PRINTING HISTORY

Corgi edition published 1979
Corgi edition reprinted 1979 (twice)
Corgi edition reprinted 1979
Corgi edition reprinted 1980 (twice)
Corgi edition reprinted 1981

Corgi Books are published by
Transworld Publishers Ltd.,
Century House, 61-63 Uxbridge Road,
Ealing, London W5 5SA

Made and printed in Great Britain by the Guernsey Press Co. Ltd., Guernsey, Channel Islands.

CONTENTS

People probably chipped these things on the walls of Egyptian bathrooms 2000 years ago. So progress is a ball point pen

Happiness is a white wall and a magic marker

Ever since Man could write he's written on walls. There is no form of literature so old or so universal as graffiti. It's been around since the days of the cave-painters and looks like being with us for the rest of time.

Graffiti can be about anything, but more often than not it's about sex. You get philosophical graffiti, political graffiti, protest graffiti, racist graffiti, graffiti about graffiti, (even graffiti that manages to be both about graffiti **and** racist at the same time: DOWN WITH GRAFFITI! **Yeah, down with all Italians!**), but for every example of graffiti that doesn't touch on any aspect of sex you'll find a dozen that do. It's always been the same, and if you don't believe me take a trip to Pompeii and read some writing on the wall that's almost a thousand years old:

Festus hic fuituit cum Sodalibus

Meaning 'this is the spot where Festus made it with Sodalibus'. it's one of the very much more innocent samples of Pompeiian wall gossip.

And if you can't get to Pompeii this year, when you're next in London make your way to Chancery Lane and seek out the window ledge on which was etched in the year 1719:

Here did I lay my Celia down;
I got the pox and she got half a crown.

And just as sex and our bodily functions seem to inspire the bulk of the world's graffiti, so the lavatory appears to be the place where we are most often inspired:

7

'There once was a fellow named Rafferty
Who went to a gentleman's laffertry,
 When he saw the sight
 He said, 'Newton was right,
This must be the centre of grafferty!'

Graffiti can be found in the unlikeliest of places — in the Reading Room of the British Museum: 'It's a funny old world. Signed, Karl Marx'; on an Egyptian pyramid: 'I've got pharoahs at the bottom of my garden too'; at the American Embassy in London: 'Remember, Yanks, if it wasn't for us British you'd all have been Spanish'; inside the Vatican: 'Celibacy is not an inherited characteristic' — but the **likeliest** place to find it is in a lavatory, and in a public lavatory at that. It's not so much fun doing it on your bathroom wall at home.

In the course of preparing this book I have visited scores of public lavatories. I have escaped both arrest and infection, but I haven't been able to avoid bad language. The lavatory wall, after all, is the home of obscenity. As one graffitist put it on the door of the staff lavatory at a school in Manchester, 'Take the four-letter word out of the classroom and restore it to its rightful place. Here.' If you don't like rude words, don't worry. I have confined them to the last three chapters, to be found between pages 86 and 107, and I suggest you tear them out and send them to the vicar right away.

The lavatory is a popular place for graffiti not only because there we usually have time to spare, but also, and more significantly, because in the lavatory we are usually alone. It is a private occupation and one that can be indulged in with confidence because all graffiti is essentially anonymous. There has been one great exception to this rule and that's my namesake, Kilroy. During the Second World War, James J. Kilroy, of Halifax, Massachusetts, was employed at the Bethlehem Steel Company's Quincy shipyard, inspecting tanks and other parts of warships under construction. To satisfy his superiors that he was performing his duties, Mr. Kilroy scribbled in yellow crayon the words 'KILROY WAS HERE' on everything he inspected. Soon the phrase began to appear in various unrelated places and Mr. Kilroy believes the fourteen thousand shipyard workers who entered the armed services were responsible for its subsequent world-wide use.

Almost all graffiti is anonymous. Almost all of it is pretty banal as well. I have tried to reproduce graffiti that is neither totally inane or simply obscene. And I have tried too to avoid

pseudo-graffiti, the sort that wits work on for weeks before writing on the wall or clever media men have teams of writers thinking up so that they can be printed on buttons and badges. All the bits of graffiti that you find in the pages that follow have been sighted on real walls by real people.

We know graffiti is something millions do and we know, by and large, where they do it. But why do they do it? You'll find all sorts of answers in weightier tomes than this — especially in **Graffiti** by Robert Reisner (USA, 1974) and **Graffiti** by Richard Freeman (UK, 1968), a pair of volumes, both brilliant and profound, from which I have culled a number of my examples) — but rather than talk of graffiti as 'environmental resistance' or 'the liberation of the aggressive impulse' I prefer to answer the question by quoting one of the very first bits of graffiti I ever collected. I saw it in the lavatory at Baker Street underground station:

Why write on a wall?
Because it's there.

Up with Down!

No doubt about it, brevity is the soul of wit and many of the best bits of graffiti are the short, sharp slogans that pack a punch and promote a cause. Some have found their way onto buttons ('If I'm awake, try me. If I'm asleep, wake me'), some have been emblazoned on T-shirts ('People who lives in glass blouses shouldn't show bones'), some have been printed onto postcards ('You don't have to be mad to work here — but it helps'), but the best work best scrawled on the place where they belong: the wall.

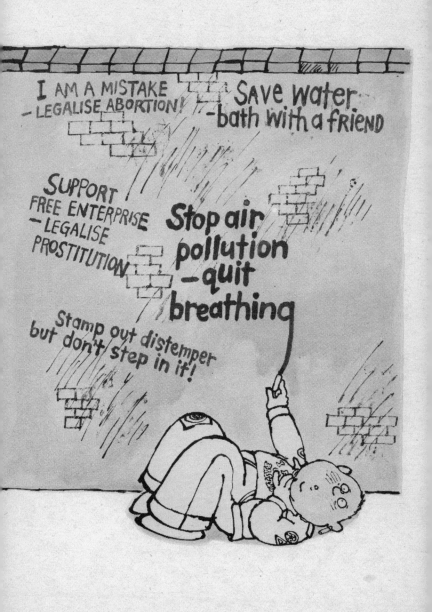

11

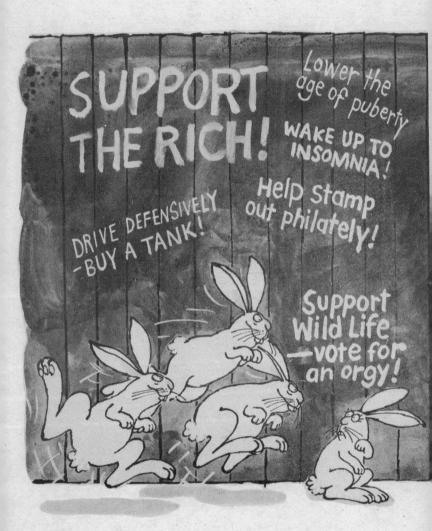

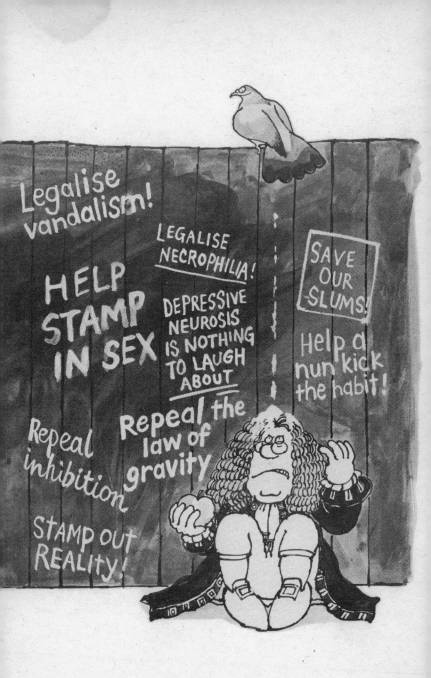

13

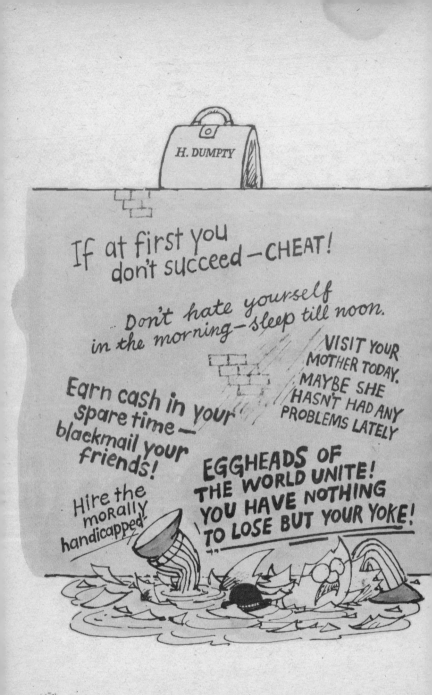

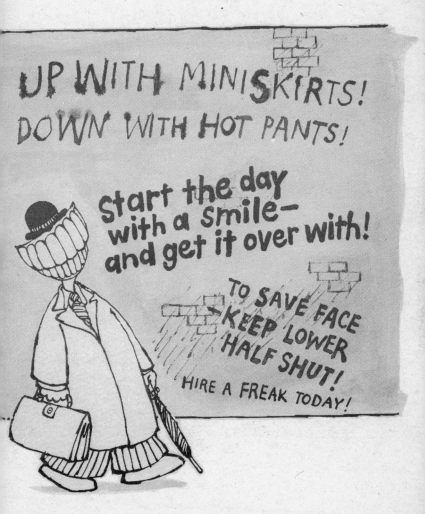

UP WITH MINISKIRTS!
DOWN WITH HOT PANTS!

Start the day
with a smile—
and get it over with!

TO SAVE FACE
KEEP LOWER
HALF SHUT!

HIRE A FREAK TODAY!

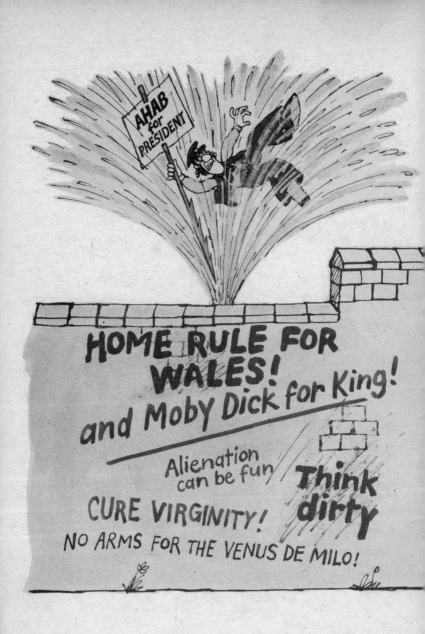

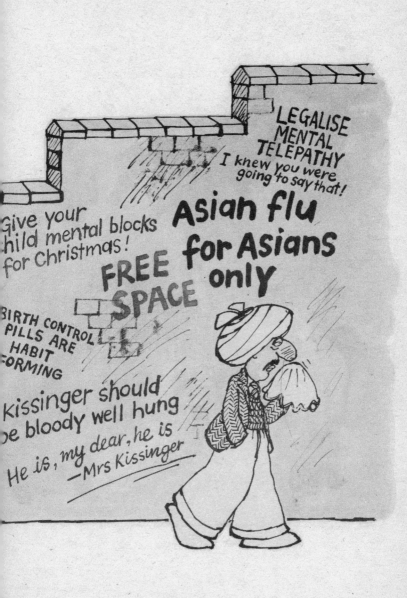

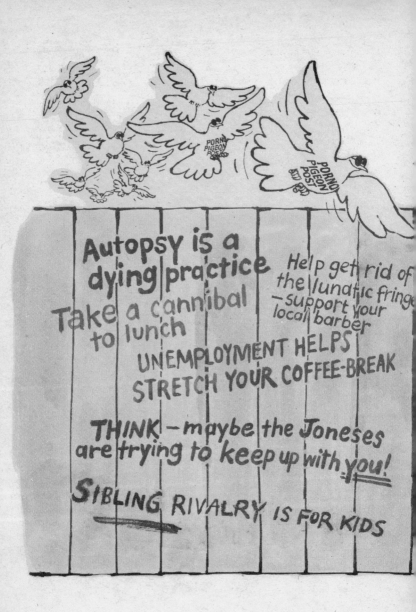

Autopsy is a dying practice

Take a cannibal to lunch

Help get rid of the lunatic fringe — support your local barber

UNEMPLOYMENT HELPS STRETCH YOUR COFFEE-BREAK

THINK — maybe the Joneses are trying to keep up with you!

SIBLING RIVALRY IS FOR KIDS

19

ENJOY A GOOD LAUGH
—GO TO WORK ON A FEATHER!

You're never alone with schizophrenia.

Support your
local police force—STEAL!

ONLY DIRTY
PEOPLE NEED
to WASH

CLEAN EARTH
SMELLS FUNNY

Children — Beat your mother
while she is young!

The Truth is the safest Lie!

In one of the men's lavatories at the University of California at Los Angeles this message was seen:

Why do you wash these walls?
Graffiti is a learning experience.

Underneath, the lavatory attendant had added:

SO IS WASHING WALLS

You can learn a lot from a wall and there is hardly any aspect of human endeavour that is not touched on by the graffitist's somewhat cynical philosophy. For some choice examples of wall-wisdom, read on.

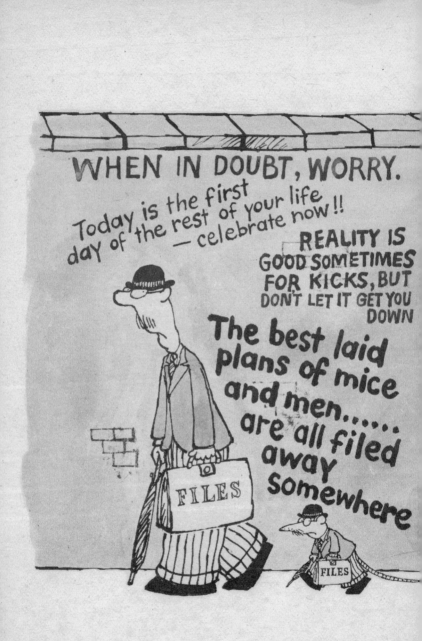

24

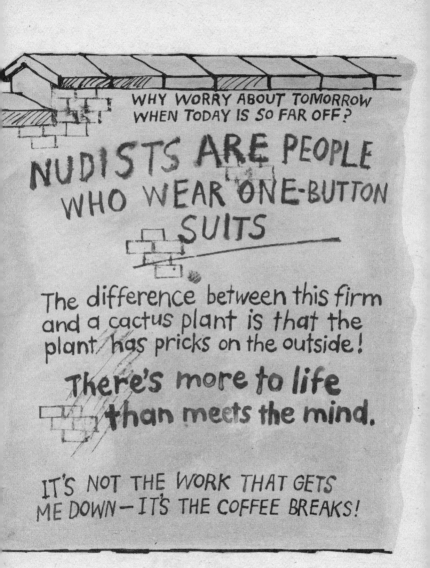

WHY WORRY ABOUT TOMORROW
WHEN TODAY IS SO FAR OFF?

NUDISTS ARE PEOPLE
WHO WEAR ONE-BUTTON
SUITS

The difference between this firm
and a cactus plant is that the
plant has pricks on the outside!

There's more to life
than meets the mind.

IT'S NOT THE WORK THAT GETS
ME DOWN — IT'S THE COFFEE BREAKS!

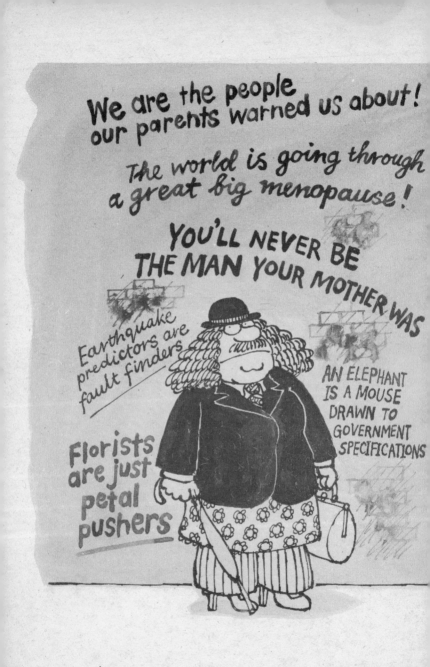

We are the people our parents warned us about!

The world is going through a great big menopause!

YOU'LL NEVER BE THE MAN YOUR MOTHER WAS

Earthquake predictors are fault finders

AN ELEPHANT IS A MOUSE DRAWN TO GOVERNMENT SPECIFICATIONS

Florists are just petal pushers

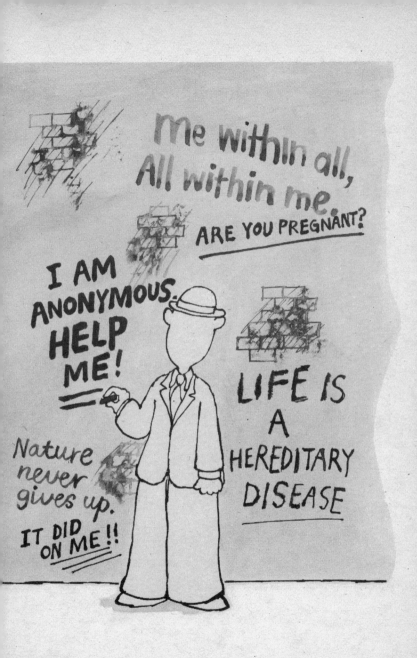

27

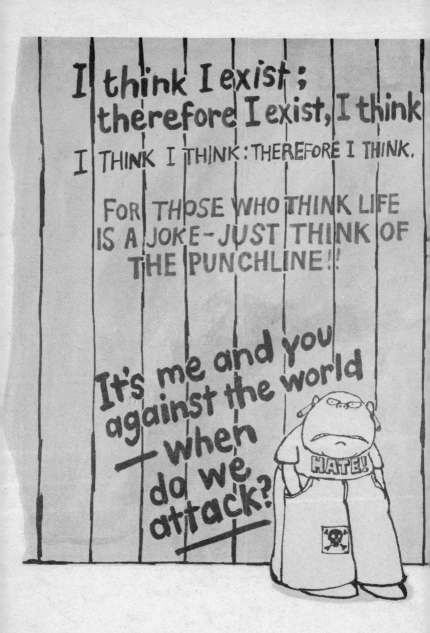

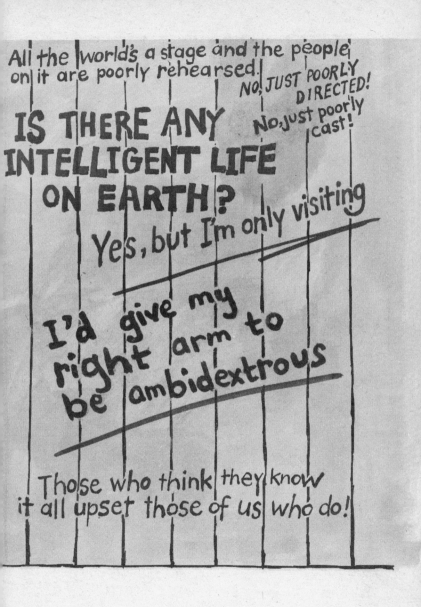

All the world's a stage and the people on it are poorly rehearsed.

NO, JUST POORLY DIRECTED!

No, just poorly cast!

IS THERE ANY INTELLIGENT LIFE ON EARTH?

Yes, but I'm only visiting

I'd give my right arm to be ambidextrous

Those who think they know it all upset those of us who do!

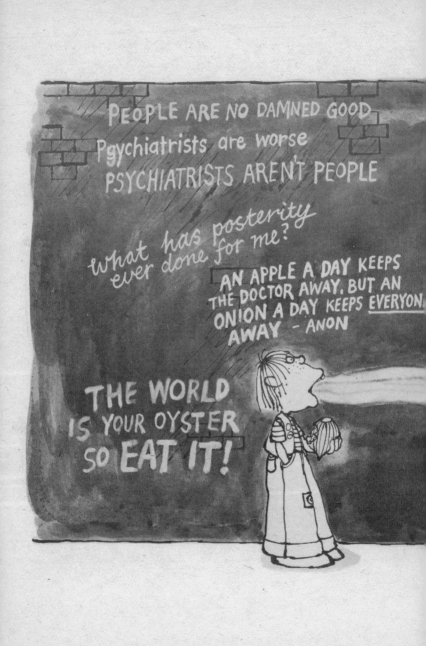

PEOPLE ARE NO DAMNED GOOD
Psychiatrists are worse
PSYCHIATRISTS AREN'T PEOPLE

What has posterity
ever done for me?

AN APPLE A DAY KEEPS
THE DOCTOR AWAY, BUT AN
ONION A DAY KEEPS EVERYON.
AWAY — ANON

THE WORLD
IS YOUR OYSTER
SO EAT IT!

Reality is a crutch!

IF YOU CAN KEEP YOUR HEAD WHEN THOSE ABOUT YOU ARE LOSING THEIRS, PERHAPS YOU'VE MISUNDERSTOOD THE SITUATION!

Alimony is paying for something you don't get!

Old soldiers never die — just young ones!

Even hypochondriacs can be ill

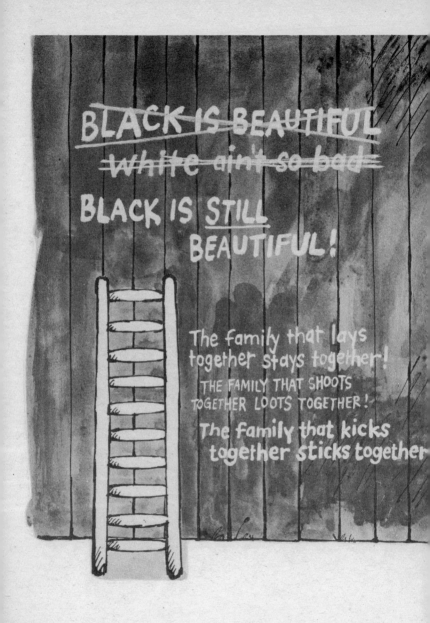

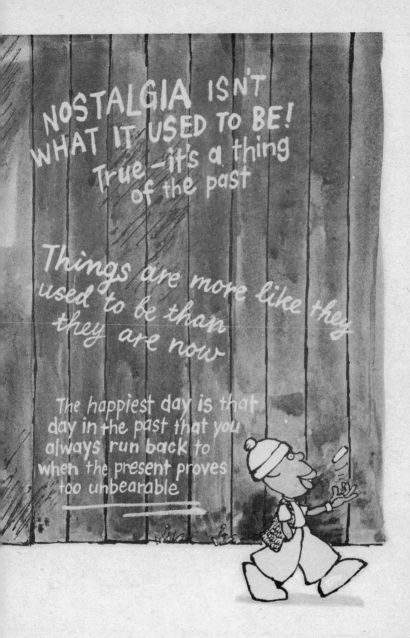

NOSTALGIA ISN'T
WHAT IT USED TO BE!
True — it's a thing
of the past

Things are more like they
used to be than
they are now

The happiest day is that
day in the past that you
always run back to
when the present proves
too unbearable

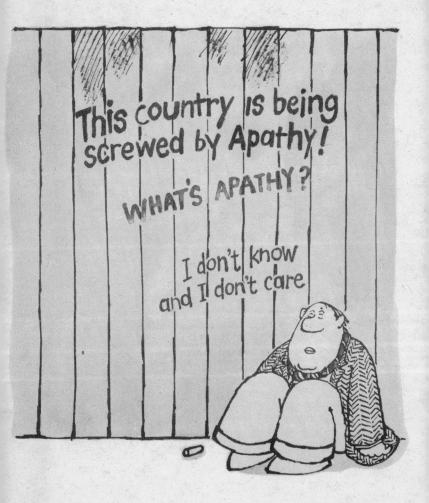

God is dead!!

On the whole, the graffitist steers clear of matters spiritual, but now and then he has a go at the Great Imponderables of Life and Death and Things Everlasting.

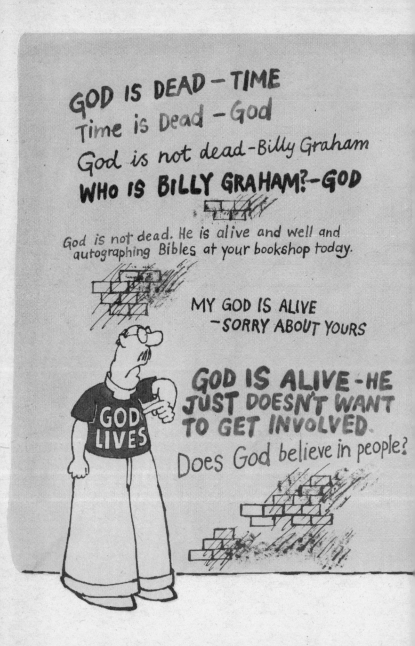

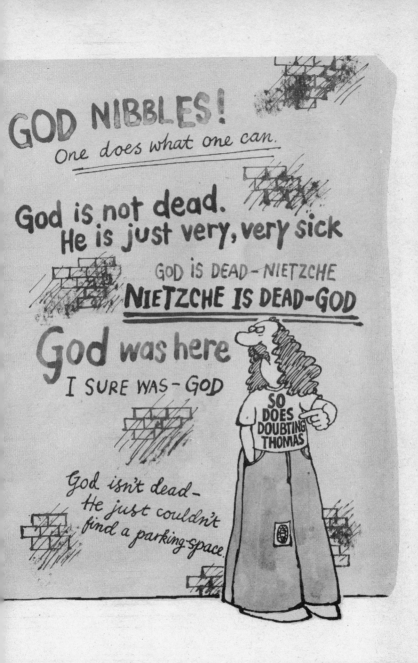

GOD NIBBLES!

One does what one can.

God is not dead.
He is just very, very sick

GOD IS DEAD — NIETZCHE

NIETZCHE IS DEAD — GOD

God was here

I SURE WAS — GOD

SO DOES DOUBTING THOMAS

God isn't dead —
He just couldn't
find a parking space.

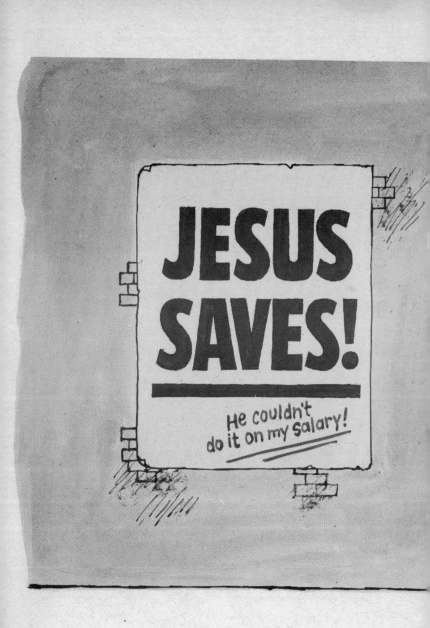

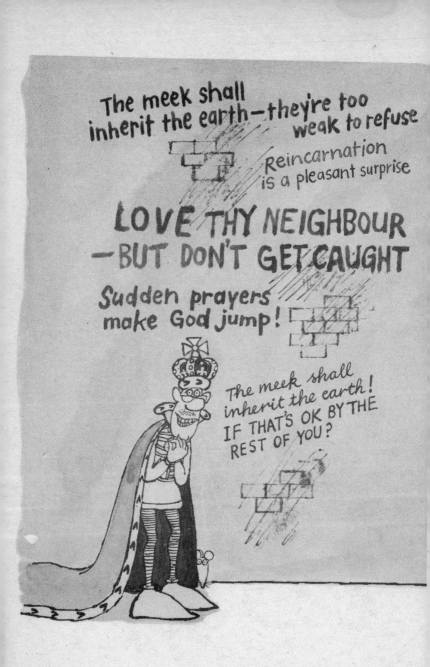

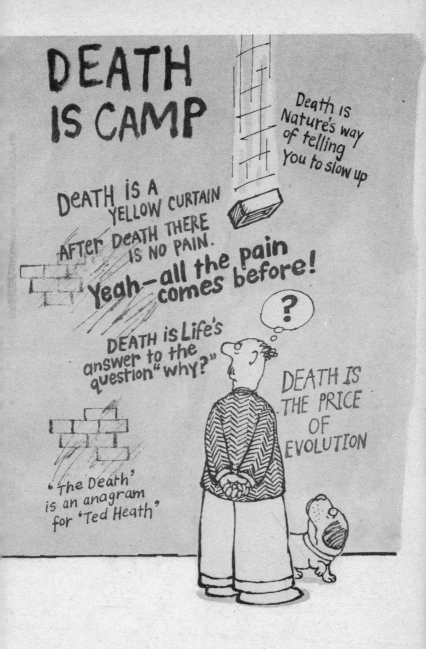

41

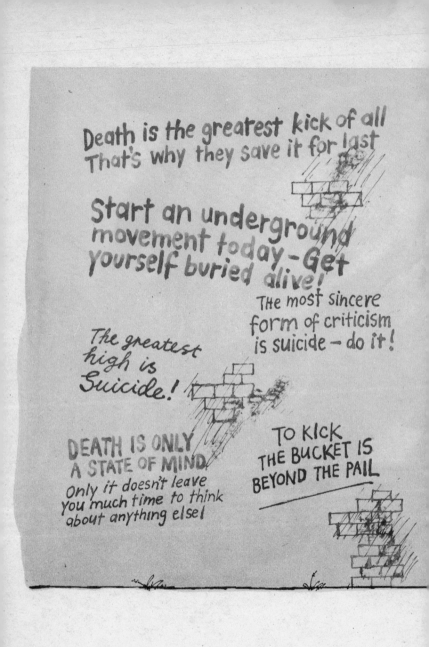

Death is the greatest kick of all
That's why they save it for last

Start an underground movement today — Get yourself buried alive!

THe most sincere form of criticism is suicide — do it!

The greatest high is Suicide!

DEATH IS ONLY A STATE OF MIND
Only it doesn't leave you much time to think about anything else!

TO KICK THE BUCKET IS BEYOND THE PAIL

Venus is a star!

If it's true that the final test of fame is to have a madman believe he's you, it's at least a sign of notoriety to have your name used in a piece of graffiti. If you want to be immortal, get yourself **scrawled** on a wall.

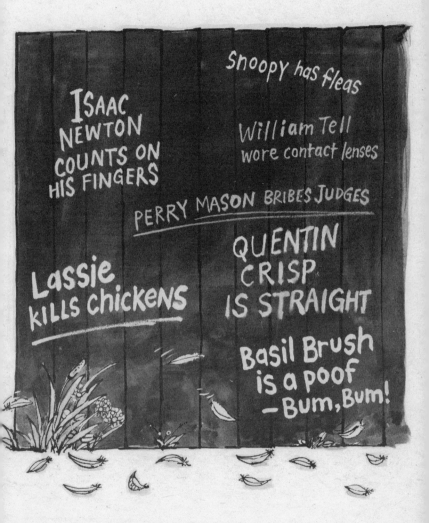

Snoopy has fleas

ISAAC NEWTON COUNTS ON HIS FINGERS

William Tell wore contact lenses

PERRY MASON BRIBES JUDGES

Lassie kills chickens

QUENTIN CRISP IS STRAIGHT

Basil Brush is a poof — Bum, Bum!

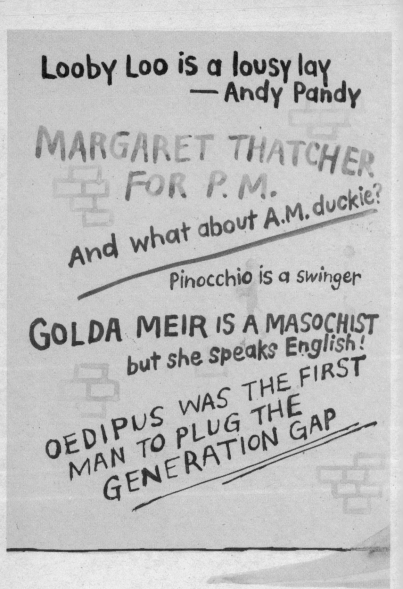

Looby Loo is a lousy lay
— Andy Pandy

MARGARET THATCHER
FOR P.M.

And what about A.M. duckie?

Pinocchio is a swinger

GOLDA MEIR IS A MASOCHIST
but she speaks English!

OEDIPUS WAS THE FIRST
MAN TO PLUG THE
GENERATION GAP

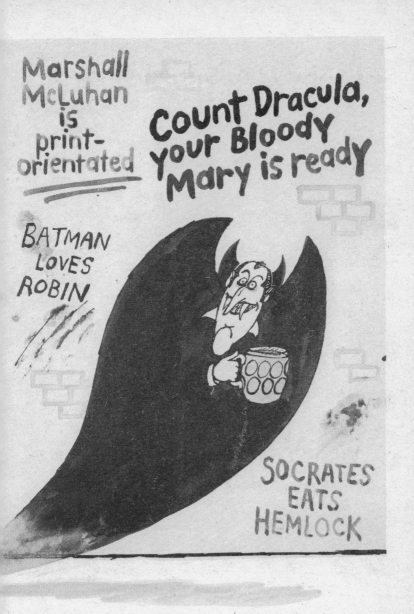

47

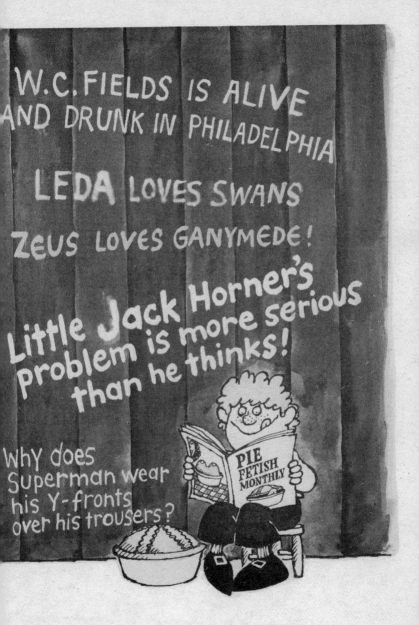

W.C. FIELDS IS ALIVE
AND DRUNK IN PHILADELPHIA

LEDA LOVES SWANS

ZEUS LOVES GANYMEDE!

Little Jack Horner's
problem is more serious
than he thinks!

Why does
Superman wear
his Y-fronts
over his trousers?

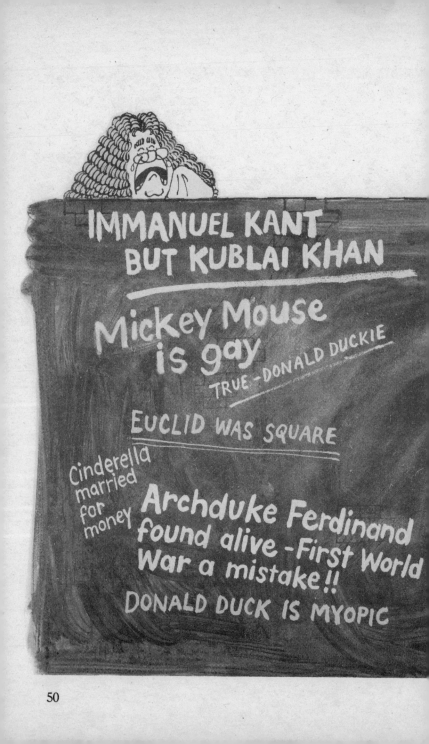

HHH HHH HHH
HHH HHH III

Rasputin lives!
He's in the kitchen

MARY POPPINS
SHOULDN'T
FLY AROUND
WITHOUT PANTIES

OLENKA BOHACHEVSKY LIVES!

And quite obviously
in great seclusion

OEDIPUS — PHONE YOUR MOTHER

Julie Andrews for inner cleanliness

51

When I hear the word gun, I reach for my culture!

Since graffiti has been described as 'wall culture', it's only right that the more intellectual graffitists should turn their attentions to the worlds of art, music and literature.

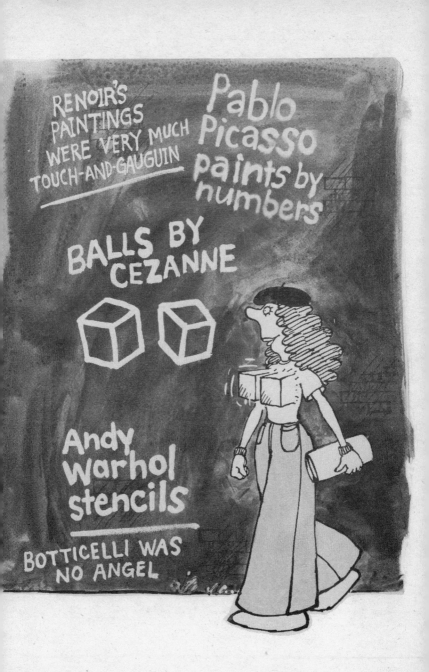

RENOIR'S PAINTINGS WERE VERY MUCH TOUCH-AND-GAUGUIN

Pablo Picasso paints by numbers

BALLS BY CEZANNE

Andy Warhol stencils

BOTTICELLI WAS NO ANGEL

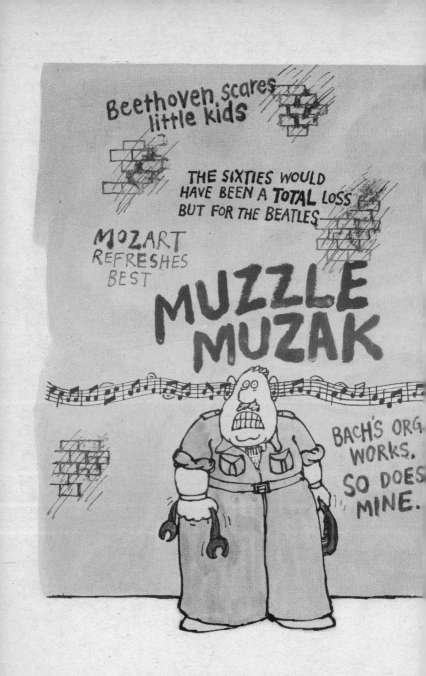

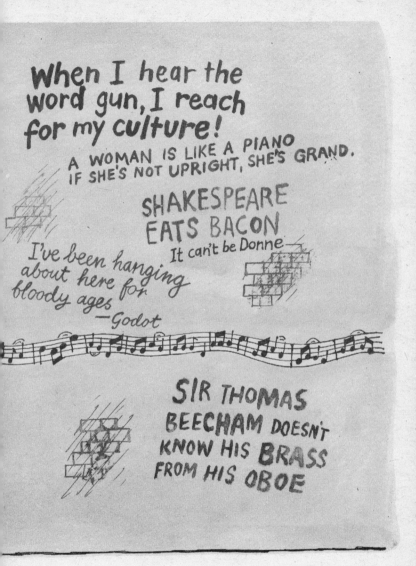

When I hear the word gun, I reach for my **culture!**

A WOMAN IS LIKE A PIANO IF SHE'S NOT UPRIGHT, SHE'S GRAND.

SHAKESPEARE EATS BACON

It can't be Donne

I've been hanging about here for bloody ages
—Godot

SIR THOMAS BEECHAM DOESN'T KNOW HIS **BRASS** FROM HIS *OBOE*

NORMAN MAILER IS
THE MASTER OF THE SINGLE ENTENDRE

That Marquis de Sade sure knew
how to hurt a guy.

CONCENTRATE ON ROUSSEAU
INSTEAD OF YOUR TROUSSEAU - Sorry I Kant

OGDEN NASH
IS TRASH

Edith Sitwell is a transvestite.
SHE'S DEAD. YOU DOPE!
O.K. Edith Sitwell is a dead transvestite.

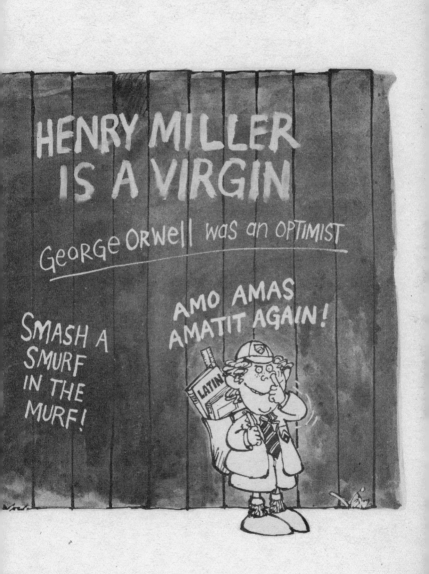

The Whole World is going to pot!

Graffiti doesn't just deal with culture: it reflects subculture too, so there were moments in the 1960s when graffiti was crazed out of its mind.

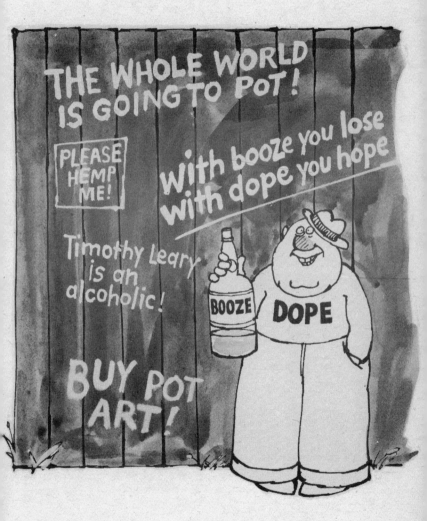

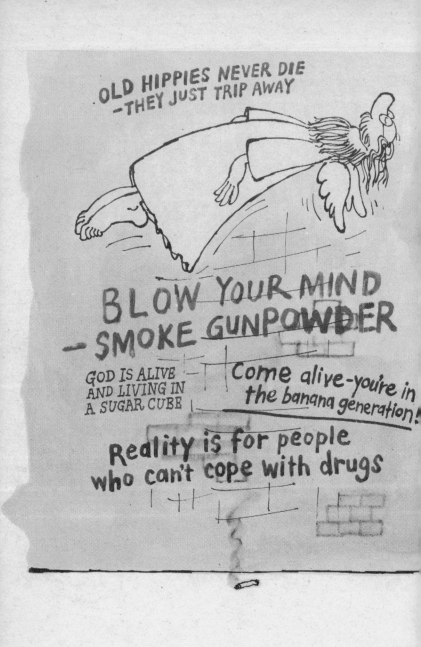

OLD HIPPIES NEVER DIE
—THEY JUST TRIP AWAY

BLOW YOUR MIND
— SMOKE GUNPOWDER

GOD IS ALIVE
AND LIVING IN
A SUGAR CUBE

Come alive-you're in
the banana generation!

Reality is for people
who can't cope with drugs

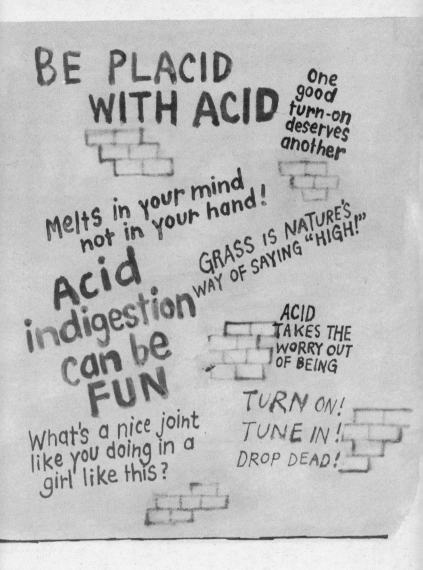

BE PLACID
WITH ACID

One good turn-on deserves another

Melts in your mind
not in your hand!

Acid indigestion can be FUN

GRASS IS NATURE'S WAY OF SAYING "HIGH!"

ACID TAKES THE WORRY OUT OF BEING

What's a nice joint like you doing in a girl like this?

TURN ON!
TUNE IN!
DROP DEAD!

It pays to advertise
—OH YEAH?

In New York City it is now an offence to sell aerosols of paint to anyone under the age of eighteen. Obviously the authorities felt that adult graffitists weren't being given a fair chance. To graffitists, young and old, printed signs and posters in public places offer some of the greatest challenges and the most satisfying rewards.

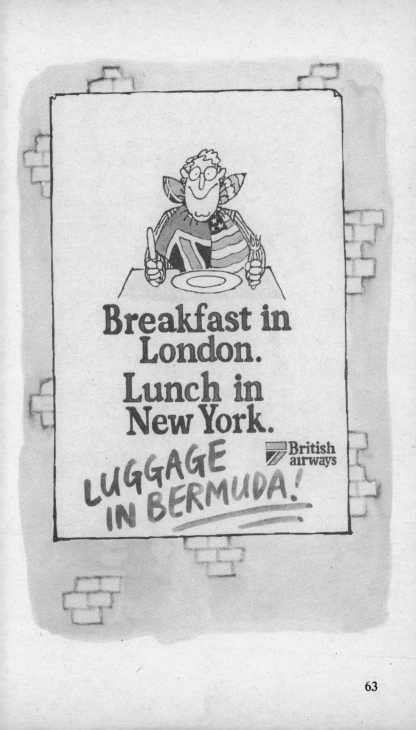

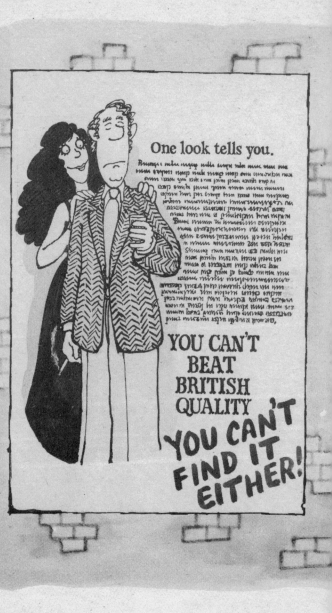

64

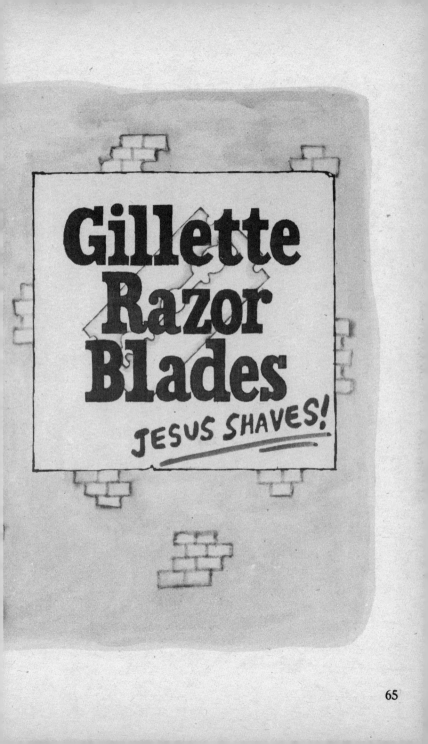

Gillette
Razor
Blades

JESUS SHAVES!

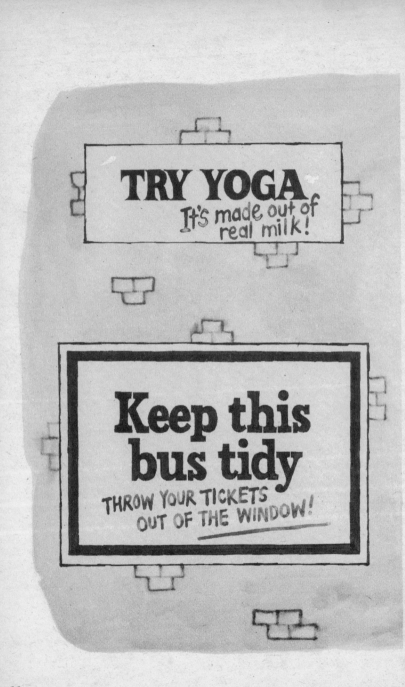

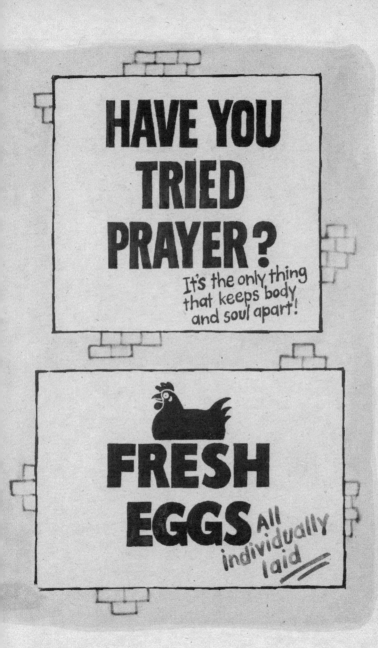

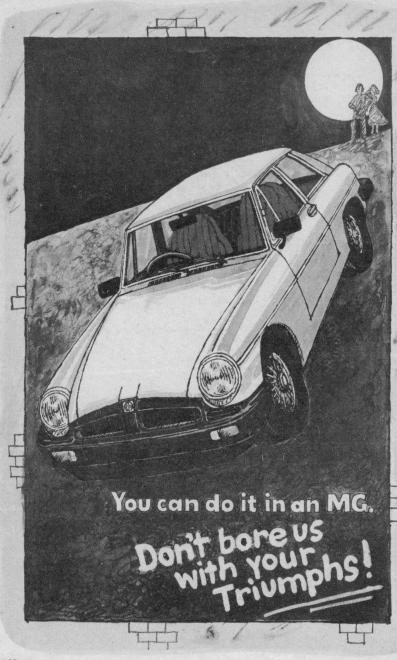

BURTON SHAKESPEARE COMPANY

PRESENTS

ANTHONY
AND
CLEOPATRA

THE BIGGEST
ASP DISASTER IN
THE WORLD!

SMOKE - CHOKE - CROAK

Rothbines
The greatest name in tobacco

The government advises you to take shorter puffs which is very unfair on tall puffs -GAY LIB

A jolly good wheeze chaps

Lung live Tobacco

Smoking brings a lump to the throat

OF COURSE, I SMOKE—IT'S SAFER THAN BREATHING!

Sends you coughing to the coffin!

CANCER CURES SMOKING

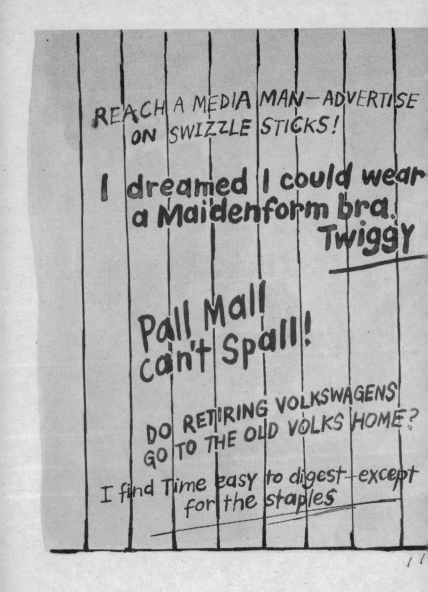

REACH A MEDIA MAN—ADVERTISE ON SWIZZLE STICKS!

I dreamed I could wear a Maidenform bra.
Twiggy

Pall Mall can't Spall!

DO RETIRING VOLKSWAGENS GO TO THE OLD VOLKS HOME?

I find Time easy to digest—except for the staples

75

Graffiti
rules — OK?

It began as a simple soccer fan's battle-cry,
ARSENAL RULES OK? It evolved into a national
cult, as much a craze as the yoyo, the hula-hoop and
the skateboard.

Einstein
rules relatively OK

QUEEN ELIZABETH
RULES UK

DYSLEXIA RULES KO

THE LAW OF THE EXCLUDED
MIDDLE EITHER RULES OR
DOES NOT RULE OK

Amnesia
rules.....er....um

Rooner Spules OK

SCHIZOPHRENIA DIVIDES
AND RULES — O.K.?

Queensbury rules—KO?

GERSHWIN RULES
— OH KAY!

Archimedes rules — Eurekay!

Mallet rules croquet?

Pooves rule — Ooh Gay?

PESSIMISTS
RULE – NOT OK!

OK
SAUCE
RULES
– HP?

TYPE RULES – O•K•

Shaking it all
about rules – Hokay Cokay

Town criers
rule Okez, Okez, Okez

Lethargy rulezzzzzzzz

FRENCH DIPLOMACY
RULES – AU QUAI ?

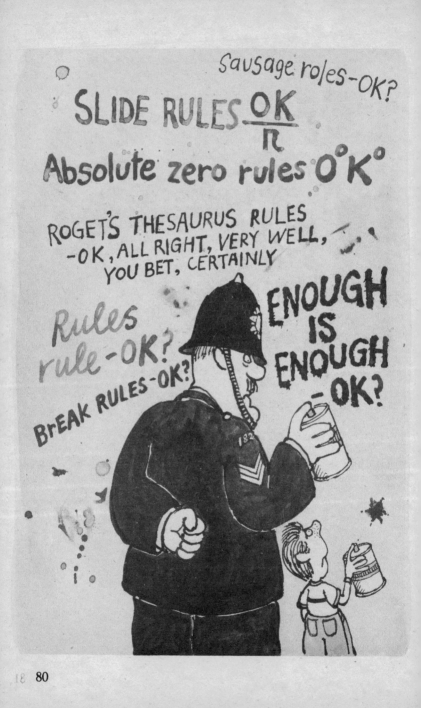

Adam loves Eve!

It is, of course, love that makes the world go round and the love-struck graffitist is nothing if not romantic.

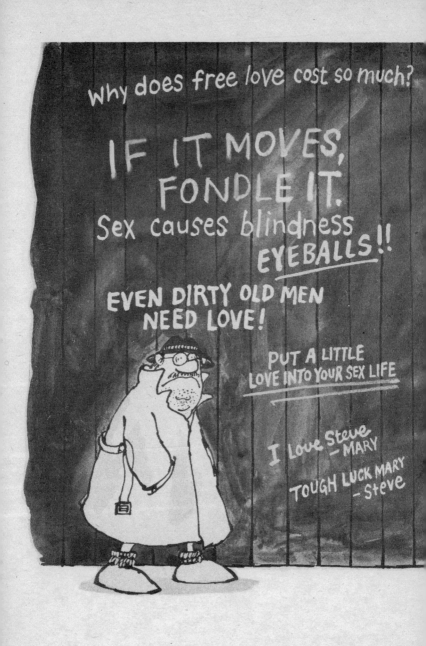

82

MAKE HASTE! MAKE LOVE!
Haste is passé and
for amateurs

CAN I HAVE
A DATE?
How about 1066?

LOVE IS A
MANY GENDERED THING.

GIRLS, WHAT DO YOU DO
WHEN YOU FIND YOUR CAT
WITH ANOTHER CAT?
Let the cats be happy
together and find a MAN!

KING KONG
TAUGHT ME
TO LOVE

This week I'm going with Bill but
I like Jim —Alice

This week I'm going with Jim but
I like Bill —Alice

**THIS WEEK WE ARE NOT GOING
WITH ALICE — BILL AND JIM**

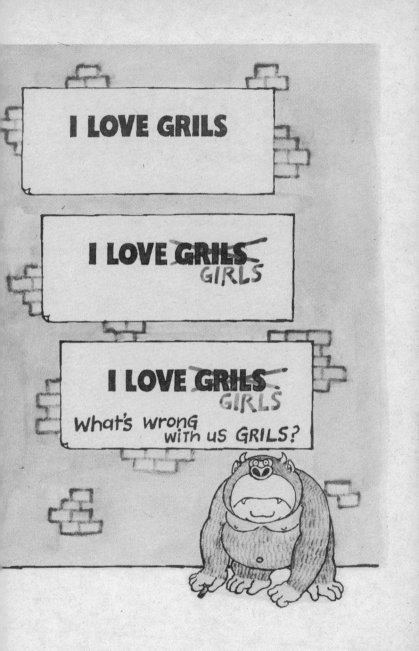

Help me!
I'm a Sex Junkie

If you can't cope with dirty words, stop here.

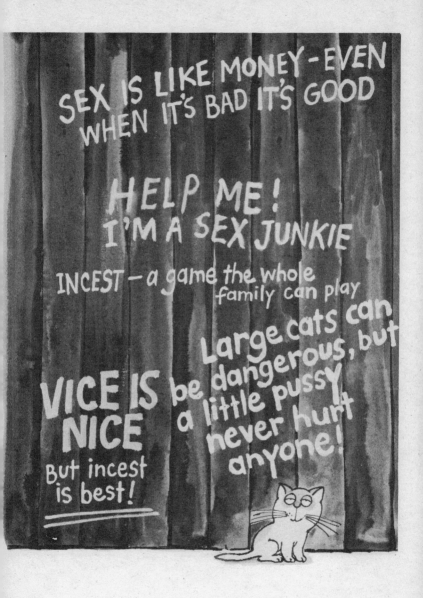

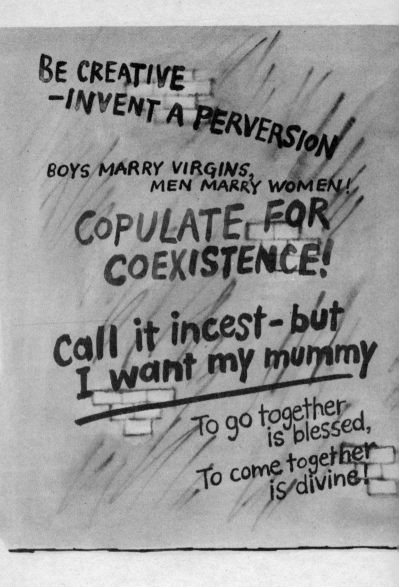

BE CREATIVE
—INVENT A PERVERSION

BOYS MARRY VIRGINS,
MEN MARRY WOMEN!

COPULATE FOR
COEXISTENCE!

Call it incest—but
I want my mummy

To go together
is blessed,
To come together
is divine!

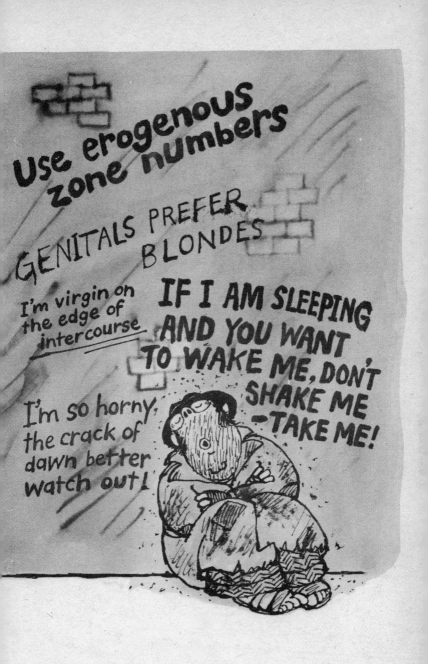

Use erogenous zone numbers

GENITALS PREFER BLONDES

I'm virgin on the edge of intercourse

IF I AM SLEEPING AND YOU WANT TO WAKE ME, DON'T SHAKE ME —TAKE ME!

I'm so horny, the crack of dawn better watch out!

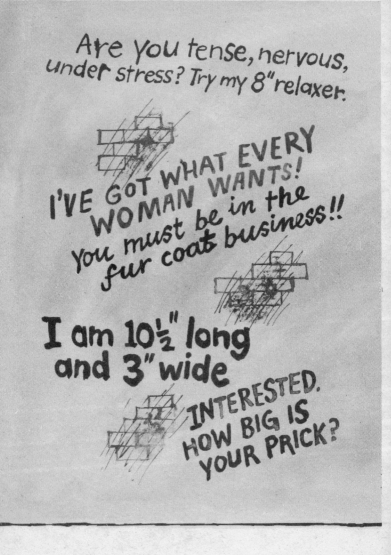

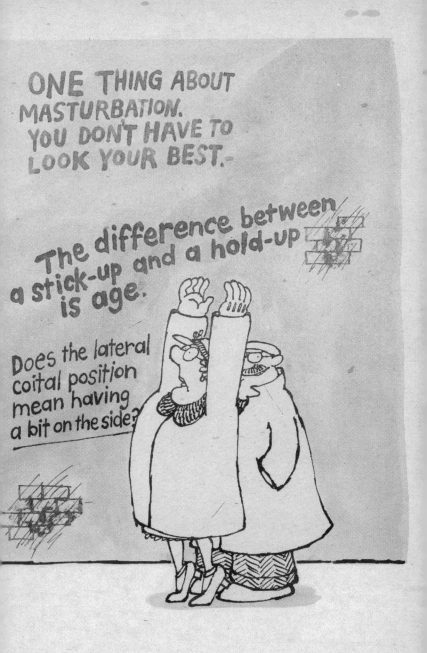

ONE THING ABOUT
MASTURBATION.
YOU DON'T HAVE TO
LOOK YOUR BEST.

The difference between
a stick-up and a hold-up
is age.

Does the lateral
coital position
mean having
a bit on the side?

God save the Queens!

As a variation on the traditional theme of Boy meets Girl, the gay graffitists offer us wall-thoughts on Boy meets Boy and Girl meets Girl.

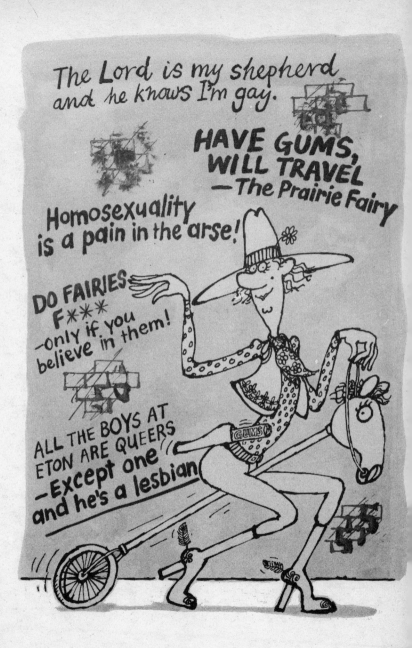

The Lord is my shepherd and he knows I'm gay.

HAVE GUMS,
WILL TRAVEL
—The Prairie Fairy

Homosexuality is a pain in the arse!

DO FAIRIES F*** —only if you believe in them!

ALL THE BOYS AT ETON ARE QUEERS —Except one and he's a lesbian

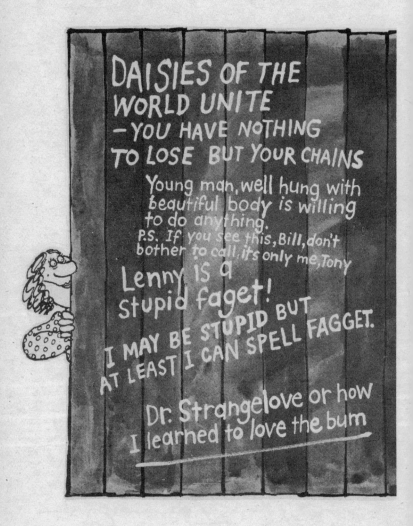

94

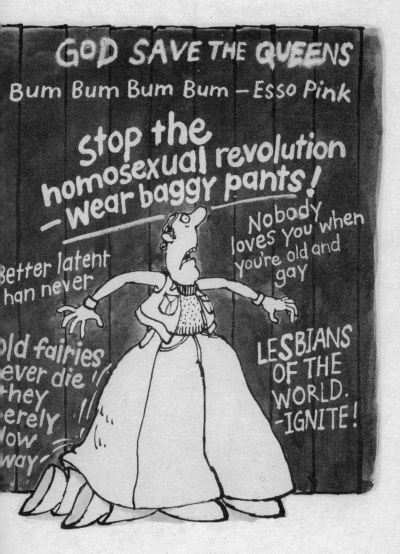

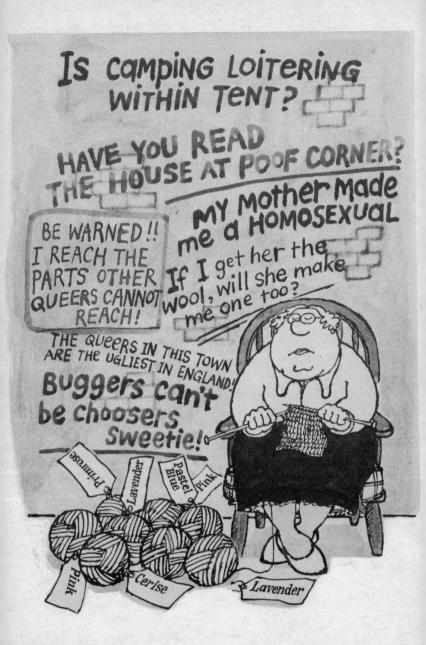

96

Veni, Vidi, Wiwi.

At last.

VENI, VIDI, WIWI

THIS IS THE PAUSE
THAT REFRESHES

Face it – this is
the most worthwhile
thing you've HAPPINESS
done all day! IS GETTING

Don't HERE ON TIME

eat

yellow

snow!

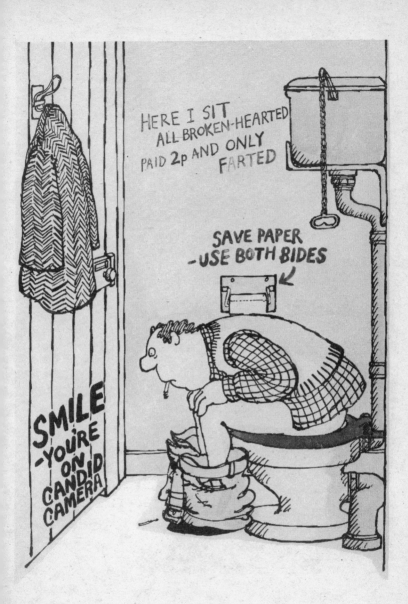

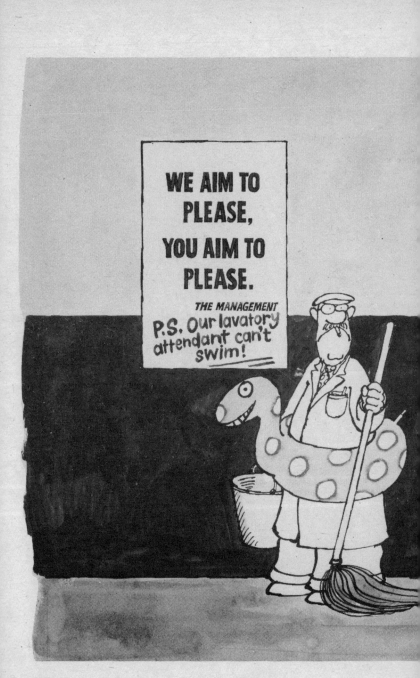

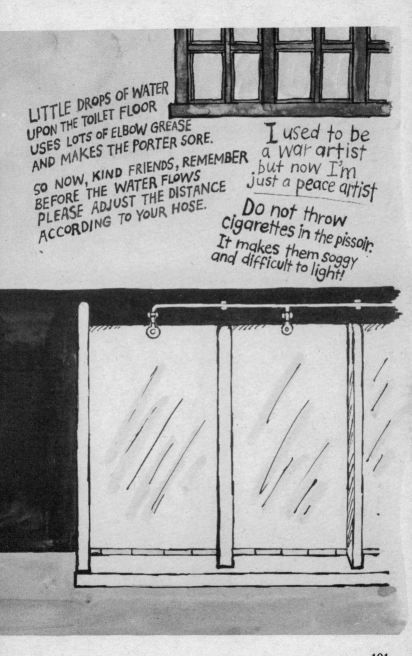

LITTLE DROPS OF WATER
UPON THE TOILET FLOOR
USES LOTS OF ELBOW GREASE
AND MAKES THE PORTER SORE.

SO NOW, KIND FRIENDS, REMEMBER
BEFORE THE WATER FLOWS
PLEASE ADJUST THE DISTANCE
ACCORDING TO YOUR HOSE.

I used to be
a war artist
but now I'm
just a peace artist

Do not throw
cigarettes in the pissoir.
It makes them soggy
and difficult to light!

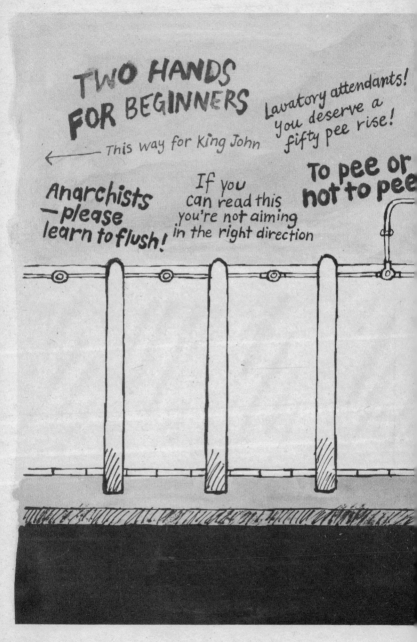

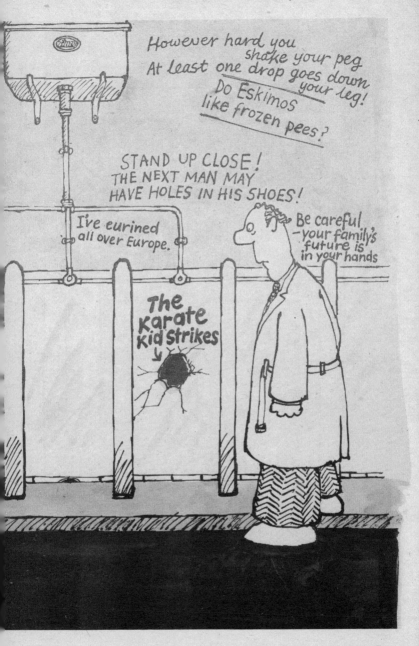

Beware the dreaded limbo dancer!

Write your own
Graffiti

Write your own
Graffiti

Write your own Graffiti

Write your own
Graffiti

Write your own Graffiti

Write your own Graffiti

Write your own Graffiti